THE RIGHT WAY

TO DRAW

PEOPLE

To friends, bless them,
who allowed me to draw their parts.

THE RIGHT WAY TO
DRAW
PEOPLE

by

Mark Linley

PAPERFRONTS

Typeset in 10pt Times by One & A Half Graphics, Redhill, Surrey.
Printed and bound in Great Britain by Cox & Wyman Ltd., Reading, Berkshire.

The *Paperfronts* series and the *Right Way* series are both published by Elliot Right Way Books, Brighton Road, Lower Kingswood, Tadworth, Surrey, KT20 6TD, U.K.

CONTENTS

1

GOOD NEWS DAY

It is good news day: you have decided to learn how to draw people, and you have limitless possibilities. You may not think so after trying to re-decorate your home, make a coffee table, or put together a fitted kitchen. However, your days of failure are over; success looms over your horizon.

We have a marvellous computer in our brain called the subconscious mind, but computer is a better word for it because that's exactly what it is. It will work powerfully and quickly for our good and just as efficiently against us, depending on how we programme it. It works like magic when correctly instructed, enabling the hardest skill to be mastered, and the realisation of our ambitions.

When we think or say 'I can', this instruction is accepted and put into practice by the computer. If, on the other hand, we have developed a negative attitude, as many have, and we tell ourselves that we can't do something, then so be it, and this message is programmed in and acted upon. Positive thinking really is easy — you can learn to do anything. Most of the times when we fail, it's due to the barriers we put up mentally. As you have purchased this book because you want to learn to draw, you are already half way to success. Congratulations!

People like to see good drawings of themselves, so you are on to a winner. When I telephoned a friend and explained about starting this book the conversation went like this: "Can I come round to draw your best parts, please?" I asked. "I haven't got any. Come to dinner and have a look at my wooden leg" came the reply. "I want to immortalise your ears" I told another chum. "You'll get a clip round yours" was the answer. Drawing folk is fun!

Enjoy learning

When learning a new skill we make the quickest progress if we enjoy doing it. Drawing is no exception. I'm sure that you are wise enough to know that you are going to make many mistakes to start with. That is part of the learning process. Don't worry in the least about blunders.

Many adults whom I have taught to draw on activity holidays began with no confidence. You should be pleased to know that after four days and five evenings almost all of the newcomers produced really good drawings, some quite brilliant. They had become positive thinkers.

Students who take the subject deadly seriously and become up-tight are slow until they relax and enjoy drawing. They then amaze themselves with their efforts. Be encouraged, and confident, for we shall start with simple exercises and only move to more advanced work as we build on success. People, our subject, are everywhere — unless this text washed up on your desert island. There are too many of us. So you will have no shortage of models. We are lucky in this respect.

Good observation is the key

Drawing is all about *looking*. If our drawing is wrong, it isn't because we are unable to control a pencil, pen or brush; it is solely due to faulty observation. If, for example, you attempt to draw a short, squat person, and the sketch shows a figure as thin as a drain-pipe, is it the fault of your pencil?

You might spot a good-looking guy or girl and want to jot down a quick record, but, somehow, the result depicts a person with a broken nose, huge ears, sunken eyes, and hair like rats'-tails. What went wrong! The *looking* of course; however, one needs to *think* as well. Artists are always asking themselves questions. How long is that nose? Which way does the mouth line go? What is the hair style like? And so it goes on. The thing to do when a sketch doesn't seem right is to go over it, mentally, and find out where it is wrong. If the correct basic techniques are learned and followed, this becomes easy with practice.

It's most important always to take a long look at your subject before putting pencil to paper. To try to draw immediately is to make the job harder for yourself.

What to use for starters

You will need a small selection of pencils: a medium hard, a soft and a very soft. These are graded HB, 2B and 4B respectively. Have a good soft eraser handy. You will also need an A5 sketchbook to pop into a bag or pocket, and a larger A4 pad for work at home. Add a few drawing pens (fibre or felt tip, fine and medium), and off you go.

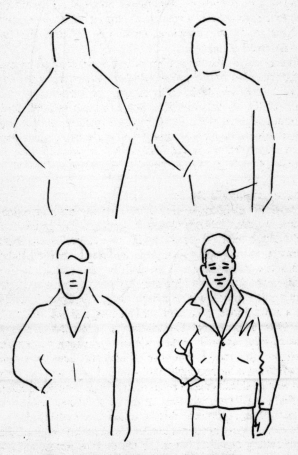

Fig. 1 Four steps to build this sketch.

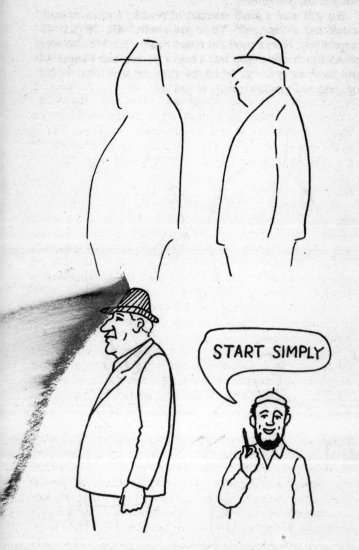

Fig. 2 Three stages to this drawing.

Simple beginnings

The best way to learn to do anything is by doing it. Your first practice should be to scribble down the basic shapes of the people around you, nothing fancy, no details. Hold your pencil naturally and fairly loosely. If the results look like rounded oblongs, that's fine at this stage. The more you draw, the quicker and better you become. At the moment, we are not bothered with achieving perfection; we want a fast impression. So, if you get a few wrong, it doesn't matter; there are plenty more to do, and, working with fast, bold, confident strokes we can churn out 20 sketches in an hour without hurrying. This may take some believing but it's true. The long, detailed studies are best done later on.

Basic shape first

Look at figure 1. This presents the four steps in building a drawing. The rough mass comes first. An idea of the shape follows. Then a few more lines begin to fill in detail, then just a few more. Getting the basic shape right is all important because, if this is wrong, nothing you do later can make an accurate picture. It's like building a shed: if the main frame is hopeless, everything else will be wrong.

Start with a soft pencil and don't hesitate to use an eraser. In the immortal words of Leonardo da Vinci, "if in doubt rub it out".

After a little practice it's possible to cut out the first two stages shown in figure 1. Experienced artists mentally construct their sketches before putting a single mark down. If you succeed in doing all these drawings at the first attempt be happy with yourself. Treat yourself to a drink, pat the cat, smile!

The man in figure 2 was very big and had a gentle face, but looked as if he could strangle an artist with one hand while breaking rocks with the other. You might try copying these drawings just to find out what you end up with. Look back at each sketch if it differs from my original. See where your *looking* went astray. Tackle the subjects in figures 3 and 4 the same way.

A mechanical tint, which is a transparent sheet composed of thousands of dots, was used on figures 5 and 6. This is to get the effect of colour or tone when printed, but better results can be obtained by you with a soft pencil. Close diagonal, horizontal

or vertical lines may be smudged with a finger to give a smooth shade or tone, which you can then highlight or darken for a photographic quality.

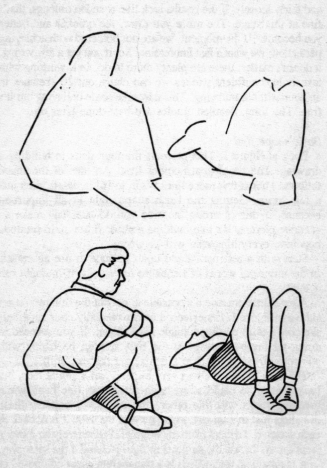

Fig. 3 Two stages.

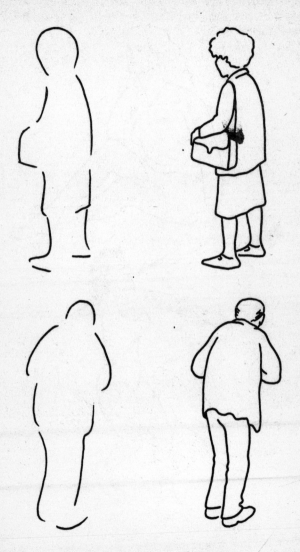

Fig. 4 Drawn from life (2 steps).

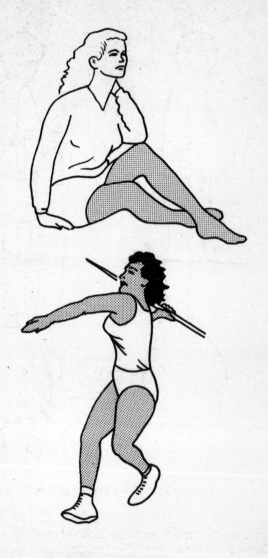

Fig. 5 Draw a little gem.

Fig. 6 Draw simply, at first.

Look at figures 5 and 6, and from the drawings construct the appropriate basic shape. Then continue through to a finished picture in pencil. When you are satisfied with your little gem

start all over again, but with a fibre-tipped pen. As your *looking* improves so will your skill. You might feel far more confident now, but don't try to gallop before first crawling, then walking. Many beginners are too hard on themselves, expecting perfection in one lesson. Be easy on yourself. It pays off.

Assignments
1. Draw 4 basic figures from photographs.
2. Try 2 sketches from life.

2

AN EASY FACE

We see human faces everywhere we go, yet drawing them, to the beginner, seems a difficult task. Perhaps some folk expect instant skill and are therefore surprised to find it so. Unfortunately, however, the ability to produce life-like pictures can only come with practice and knowledge.

To be good at this branch of art is rewarding. A competent portraitist can soon have a queue of customers, each eager to part with fistfuls of money in exchange for a good drawing of themselves. People seem always to enjoy — and wish to own — an original portrait of which they are the subject. We are a vain lot, this author included.

Directly you show an ability for getting a likeness of your subject in your sketches, you can also expect invitations to parties, complete strangers to become immediate friends, and limitless other possibilities.

Remember: start by jotting down the accurate outline — don't bother with details until later.

Profile and frontal

It's vital to fix in your mind the basic shapes of a skull, front and side. Look at figure 7. Notice how the outlines can be simplified into sound structures on which to build a drawing.

Think of a head as being like an egg with the broad end on top (frontal view). Half way from the top to the bottom of this is where the eye line is. Then, half way between the eye and bottom of the jaw, is the underside of the nose. Half way between the end of the nose and the chin is where the mouth line should be.

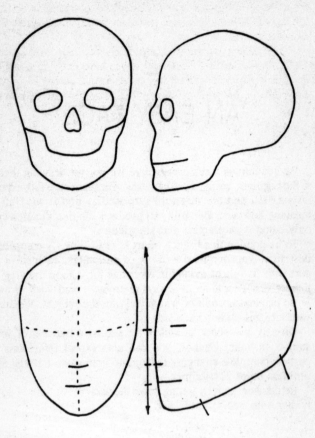

Fig. 7 The skull shape.

This same guide applies to a head in profile, but the shape from the side is different because the skull extends further back. Looked at from the side the structure of a face is still rather like an egg but one with a flattened side. Notice how dotted lines, lightly drawn, will give you the correct positions for eyes, nose and mouth. And how the neck lines have also been marked on

the example in figure 7. The neck does not pop straight up from the top of the body. It comes out at an angle which varies with each individual.

While these proportions give a fairly accurate form to work from, remember that faces vary; some have long jaws, or high foreheads, or narrow faces, and so on. Just as an egg is rounded so is a head. We soon discover the differences when we work.

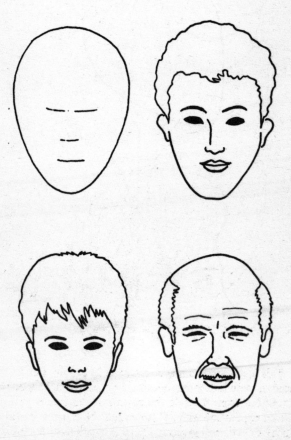

Fig. 8 Outlines first (frontal).

Take heart that, provided you start by putting down, in faint lines, the general outlines as I have just explained, your drawings will always be on the right track. This way only minor adjustments should be needed later.

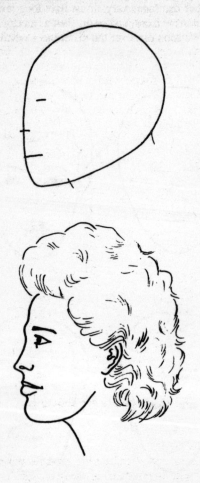

Fig. 9 Basic shape first (profile).

See the faces in figure 8. Copy them — outlines first, remember! Next have a close look at the profile in figure 9, and do the same exercise.

Ear here

A common mistake when drawing a face in profile is to put the ear in the wrong place. It's much further towards the back of the head than is often imagined. See figure 10. The distance from the outside corner of the eye to where the back of the ear comes, should be roughly equal to the space from there to the bottom of the jaw. This, of course, will vary slightly between individuals as do all other features. Now you have a little more knowledge to help you.

Fig. 10 Where the ear should go.

Turn your head

After practising frontal and profile sketches we move on to find out what to do when a face is *partly* turned. The drawing procedure is the same although we are seeing the person from an angle. Think of the egg shape and of how those dotted frontal

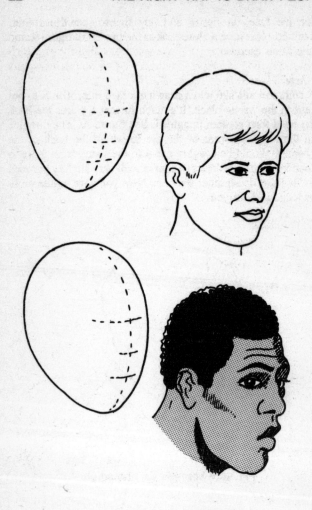

Fig. 11 The structure lines.

position-lines would give an illusion of a curve if the egg were turned; then build your drawing on the right structure, and you are winning. See figure 11. The bottom head has been shaded

simply by close, even lines, and the hair has been blocked in.
Try this technique in pencil to begin with. Constantly remind
yourself how the oval basic shape must vary slightly with each
subject. Practise drawing your basic facial shapes using the
finished illustrations in figure 12.

Fig. 12 A little more detail.

Bits and pieces

For now, don't worry about drawing too much detail in the face. We shall be dealing with this later on. One of the many interesting things about recording the human face is the way we all differ from each other in every feature, identical twins excluded. No two mouths, noses, or even nostrils are the same. Each pair of eyes is unique. Most of us have uneven faces. One side is by no means symmetrical with the other. So the drawing job requires careful looking.

To stare at an intended subject can be disconcerting so it's better to practise, to begin with, on friends and relatives. You may find that they become rather rigid or shift about a lot. However, be patient; use your humour; then plod away. Your model will soon relax.

Lots of choice

A good source of static models can be found in daily newspapers. Their pages are full of faces; however, many grin out at the reader. Avoid these, and try to sketch from the serious, or candid shots.

It is wonderful practice to wander about with a small pad and quickly jot down impressions. The drawings in this book were done with a drawing pen and black ink. However, you will find that a soft pencil makes the job simple, and you can obtain tone and texture to a very fine standard.

Assignments

1. Draw 4 frontal faces after putting down the basic shape.
2. Draw four profiles in a similar fashion.
3. Try four sketches of angled faces.

3

A NOSE AND A BIT OF LIP

We'll start with a word about how to sharpen your pencil.
Rather than resort to a pencil sharpener, most artists prefer to
use a knife or cutting blade to fashion the business end of the
lead. This allows them to create a chisel point on a pencil, which
is useful because it gives a wide edge for thick lines or shading,
and a thin one for fine lines. See figure 13.

The eye you use the most is your master eye. It is usual to
have a master eye matching whether you are right or left handed.

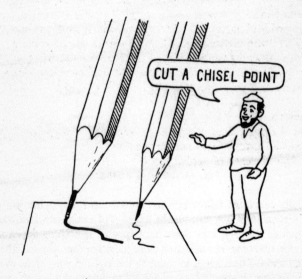

Fig. 13 A professional pencil point.

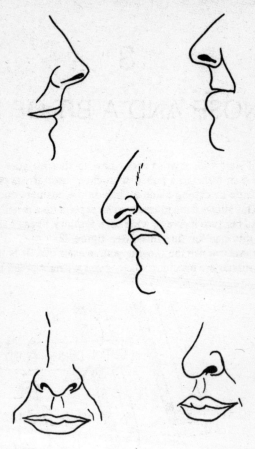

Fig. 14 Different noses.

You can check the following way: hold a pencil up, in line with any vertical item (which could be the edge of a door or window); then close your left eye. See what happens. If nothing appears to move, open that eye and then close the other one instead. The pencil should then seem to jump to the right if your right eye is the master. It should have appeared to bolt to the left as you closed your left eye if that one is the master.

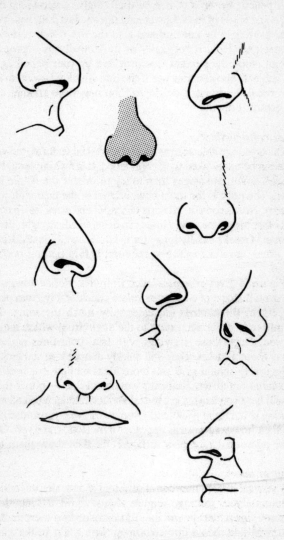

Fig. 15 Nostrils.

A pencil, by the way, can be used to give a good idea of the slope and angle of the subject being drawn. Just hold your pencil at arms' length by one end and shut the eye which is not your master one. Hold it vertically or horizontally as appropriate. Squint along the straight line provided by your pencil against the subject. You can then see if the line which you want to draw is vertical, horizontal, or slopes. You now have another aid to successful drawing.

Nose construction

Once you are able accurately to draw facial features, the whole face can be undertaken with confidence. It is far simpler to break the job down into stages than to try to master the whole lot at once. The nose is the most obvious part of the face with which to start. Noses come in all sorts of shapes and sizes, as do cheeks and other bits of the face. Noses can be crooked, straight, droopy, Roman, Greek, small, long, thin, fat, or, well, just different! As usual, careful *looking* is required before putting pencil to paper.

Figure 14 gives examples taken from life. Notice how, whilst the overall shape of each nose varies considerably from person to person, the nostrils are essentially much the same. They mainly only differ according to the angle from which they are viewed. Copy these drawings with fast, bold lines and don't worry about mistakes. They will quickly disappear as you progress.

Figure 15 should give you more ideas on how our breathing apparatus can differ. Your own wonderful face — plus a mirror — will help you learn a great deal about a human face and about *looking* properly at a subject! Observe the way your nose is put together, how your nostrils appear as dark slots, and so on. Study these additional examples in figure 15; then draw them too.

A bit of lip

There are a huge number of different mouth shapes, and this feature changes with age. Figure 16 just shows the mouth line between upper and lower lip. You can see that there is never a straight line. Most lips are curvy, with a dip in the middle of the upper one. Mouths can also be uneven, one side being different from the other.

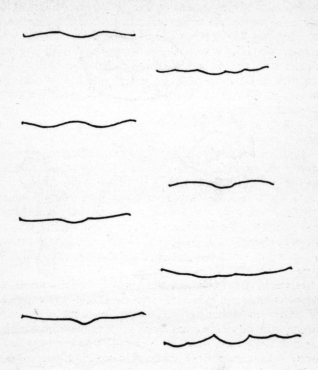

Fig. 16 Mouth lines are wavy.

It's getting these small, and not so small, variations right that can turn a mediocre sketch into a genuine likeness. How do we get them right? By *looking!* Doing so properly becomes easy with practice.

Look at figure 17. These illustrations of lips reveal the way lips are creased by small lines which follow the curve of the flesh. The lines can be deep or faint, many or few, and they tend to be criss-crossed in the elderly. A tip worth remembering, however, is to leave out many of these marks. Otherwise the finished mouth can look like crazy-pavement.

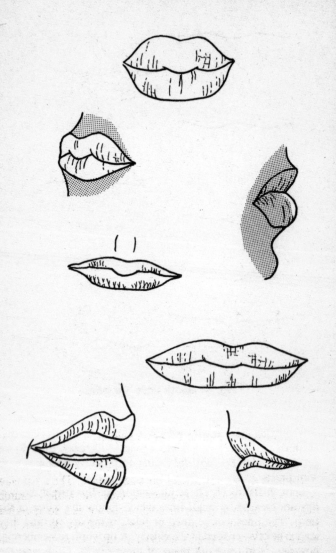

Fig. 17 Lips in detail.

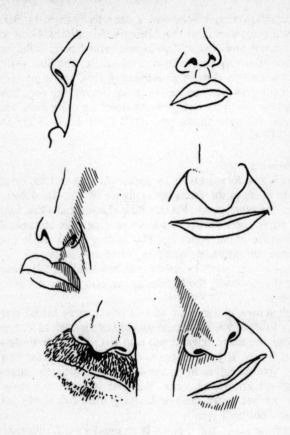

Fig. 18 Different angles.

Teeth are best left blank for the same reason. The artist who draws people resembling mutant creatures from a black swamp might have a future in horror comics but not as a sought-after portrait specialist. Maybe your spouse's in-laws do look like monsters to you but there's no need to depict them so. Be kind to your victims and they could be good to you!

Folk are quick to praise a good picture of themselves but

quicker still to criticise a bad one, or one which ages them. Being accurate in drawing is all about being self-confident. Once you have become proficient at drawing the various parts of the face it is then relatively easy to attempt the whole. The time swiftly comes when you glimpse an interesting face, say to yourself, "yes, I can draw that one", and you do! Get into the good habit of thinking positively and mentally sketching every face. Your progress will soon amaze you. YOU CAN LEARN TO DO ANYTHING.

Put them together

Take a step forward now, by drawing a nose and the mouth beneath it, as in the examples in figure 18. See the different angles. Try other views. Put in a little shading and a few facial lines. Notice how we have a groove running from our nostrils to the centre of our upper lip. This is drawn as a single line, two lines, or left blank, according to what is seen.

Observe yourself in a mirror to see how shadows fall. There is one shadow under the bottom lip, another under the droop of a nose.

Look at the way things are when a face is partly turned away from or towards you. If you use yourself as a model, as Vincent van Gogh did many times, it will help you to have two or three mirrors handy. If you don't own more than one mirror don't worry; you are following in the footsteps of the now-famous poverty-stricken impressionist. But there is no need to lop off an ear just yet — we shall be studying these bits in the next chapter. Wait until then!

Sketching noses and mouths is straightforward, and many quick drawings can be done in an hour or two. You may have discovered that, when drawings begin to improve, the subject becomes addictive and pictures simply pour out! Although drawing-pads are not too expensive, a more economical material to use is good quality typing paper purchased by the ream (500 sheets).

I needed between 40 and 70 roughs and original drawings per chapter to produce this book. An output like this would use up an awful lot of sketch pads, so I worked on typing paper.

It's wise to churn out many drawings rather than to make just

a few meticulous ones. Quite often a fast, spontaneous effort can't be bettered.

One of the reasons for copying the examples given, is to help you to become quick and accurate and to draw with simple lines. Most beginners tend to try instead to put down every line. They end up with a mess. Experienced artists suggest form and shape with as few lines as possible. This makes for less work and an easier life, which is something we all aim for!

Assignments
1. Ask four people you know to pose for you. Draw their noses and mouths. If you live alone, or can't get about, use newspaper photographs.
2. See how many noses and mouths you can sketch in pencil within one hour. Model them on photos in magazines, catalogues, albums — wherever they may be close at hand.

4

EYES AND EARS

Eye, eye, eye

Drawing the eye needn't be as difficult as some newcomers to art make it. The part we see isn't round except in newly born babies. The bit we want to sketch is shuttered by upper and lower lids, and is fringed with eye lashes. It's the surrounding pieces which confuse and tend to put beginners off. The answer to the problem is to study and learn to draw each item, one at a time.

As with all facial features, with eyes there is a great variety — without which we would be a pretty boring lot. The examples in figure 19 cover both sexes and a range of ages. The actual shape of most eyes is rather like a tear drop laid on one side. The one common factor we see is the duct at the inner corner of each eye.

Notice the differences in eyelids; they can be thick, thin, heavy, bulging or hardly visible. The lower lid usually shows a rim from which fine lashes sprout.

Bags beneath eyes cast a tiny shade. Just as the chin throws a deep shadow on the neck, the brow causes eyes to be indistinct.

We all favour one of our eyes, the master eye, and this has an effect on its lid as we grow up. As a result, when we study grown-up people, few have a perfectly matching pair.

Ladies have prettier peepers than men as a rule, and they can enhance their long lashes with make-up. This helps to make the drawing of their eyes a little bit easier.

The size of the pupil (the dark circle in the middle) varies according to the light, and the vision of the person concerned. When drawing eyes remember to leave a white spot on the pupil. This is reflected light which gives life to an eye. The area immediately surrounding the pupil (the iris), is drawn by fine lines which radiate out. Dark eyes are recorded by dense shading

or are blocked in.

Try sketching the eye shapes from figure 19, until you can quickly put down accurate copies. This task should take all of

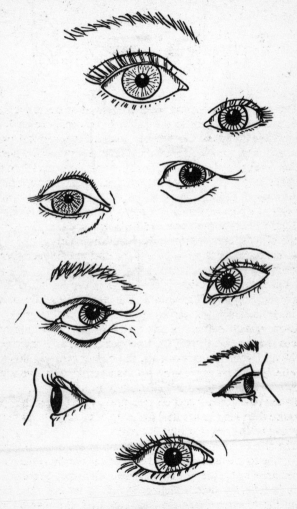

Fig. 19 Eye close-ups.

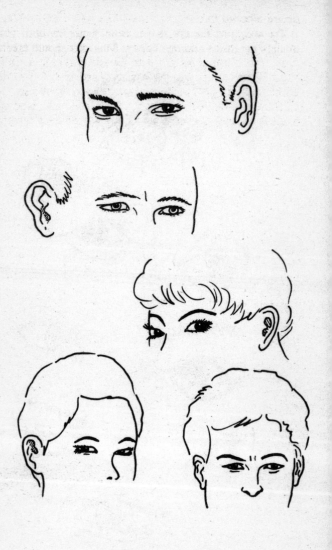

Fig. 20 Position of the eyes.

ten minutes for a confident person like you. Then add lids and
lashes and maybe a few face lines as well. Remind yourself,
by looking again at figure 10, how far back the ears are on the
head. The illustrations in figure 20 add to that knowledge by
showing the relationship between eyes and ears. Copy them; it
all helps to fix in your mind the way each feature is.

The eye in figure 21 is that of a nice young man who agreed
to act as a model. See in the top view how the hair of the eyebrow

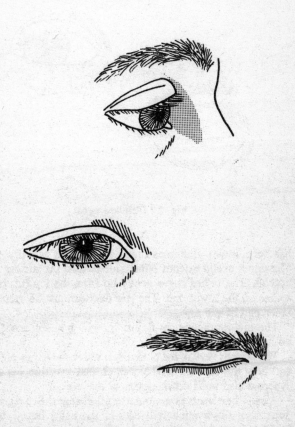

Fig. 21 Close-up details.

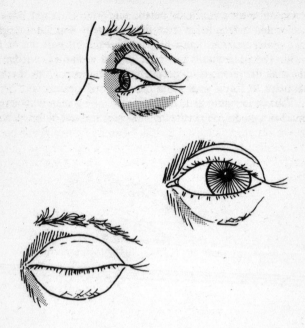

Fig. 22 Detailed eyes.

has been drawn, fine lines running the way it actually grows. The upper eyelid extends either side beyond the surface of the eyeball. The lashes curve gently up from the top lid, but are sparse on the lower one. The tear duct can just be seen at the inner end of the eye.

The middle picture, in figure 21, will give you more clues on how to draw eyelashes.

The bottom view of the closed eye, shows the fringe of lashes, and how the shut lid is sketched as just two thin lines. The eyebrow also pulls down nearer to the eye.

Alas, when we become older it all changes. See figure 22. Your keen observation will take in the bags, lines, straggly eyebrows, and thinning lashes. No, it's not an illustration of your author's eye; his is much worse!

Copy these examples, in pencil, using thin and thick lines as necessary. Then go over your masterpieces with a fibre-tip pen just so that you can see what each medium does.

You should be aware that most folk are seen from a distance, and that their eyes are not clearly visible but appear just as dark shadows. This will apply to the majority of subjects you sketch from life, around town, in a supermarket, or wherever they may be. Bear it in mind. It will save many mistakes and much time if eyes are simply blocked in as in the early figures in this book. It's possible to do this and still obtain a good likeness. Take a careful peep at the people in figure 23. Then attempt to draw them.

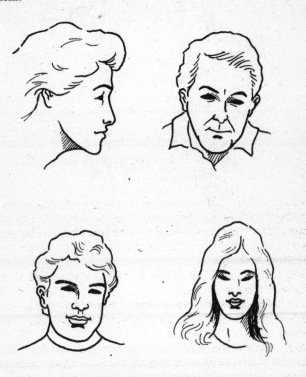

Fig. 23 Blocked in eyes.

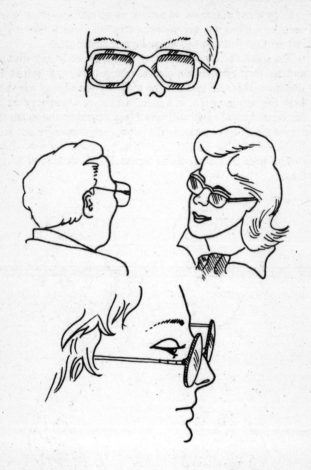

Fig. 24 Notice the different types of frame.

Glasses

With age eyesight deteriorates, and most of us eventually trudge off to an optician, later to emerge self-consciously wearing spectacles. At least they help us to see our victim in sharp focus again!

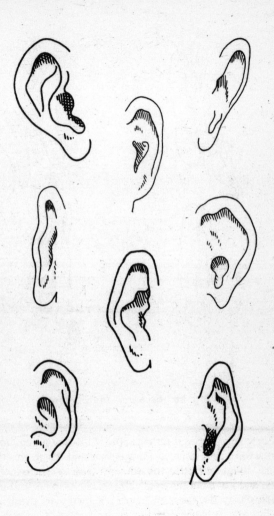

Fig. 25 A selection of ears.

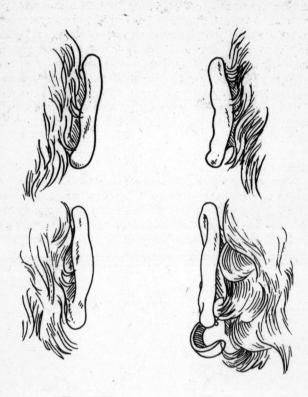

Fig. 26 The ear – from behind.

Sketching glasses is quite simple but it is exacting. You need to practise a little technical draughtsmanship. There are countless frame designs around to observe. It's best to sketch the frames only, and leave out the eyes unless a close-up portrait is being made. Study the specs in figure 24; then copy them.

Ear, we go again!

Ears are very interesting to draw because each person has a unique pair. Some are easy to jot down but others require much

thinking about and a lot of *looking*. The ear is dish-like, with a turned-over rim designed to catch sound and channel it down to the ear canal. They come in all sorts of sizes (and abilities to listen!), with many variations of the basic shape, and they may well have unexpected lumps and ridges.

Figure 25 contains just a few ears encountered in an hour or so. See how they have been drawn. Then have a go yourself. The ear seen from behind is quite another shape, one which is more like a rim stuck on the side of the face. Figure 26 is next on your list.

Assignments
1. Draw the ears of four people, both from the side and the front.
2. Record accurately the eyes of a young person, those of a middle-aged lady and a pair belonging to an elderly man.
3. Draw someone in glasses from the front and from the side. In this exercise do not bother about other features.

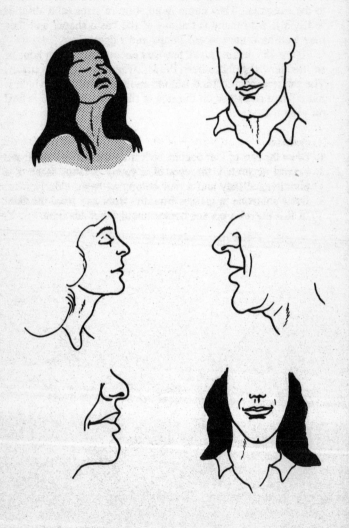

Fig. 27 Draw different jaws.

5

DRAW UNDERGROWTH

Jaws

I was not fully aware of how popular moustaches and beards are until I began this book. The hairy undergrowth beneath some noses and on many jaws adds interest to the face, and provides another item on which to exercise our artistic skill.

Jaws, you may know, vary with age and sex. A glance at figure 27 will reveal just a few for you quickly to scribble down. By

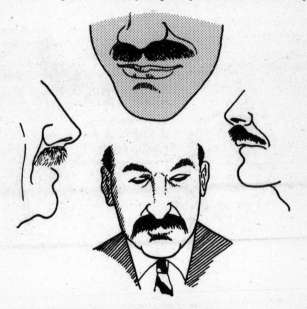

Fig. 28 Put the undergrowth in.

now, you should be quite good at recording facial features, which means that the more advanced work in this chapter can confidently be taken in your stride.

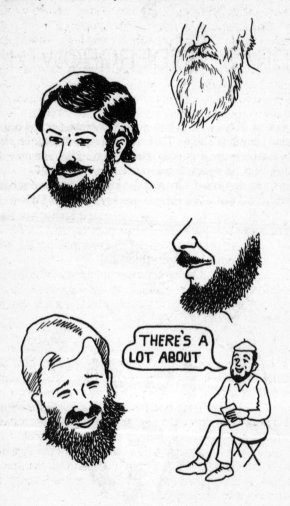

Fig. 29 Beards are popular.

Moustaches

Men, from around the age of sixteen, can grow moustaches and beards, and why not? This desire seems to be natural for fellows, just as it is normal for those ladies who so wish, to grow their crowning glories to great lengths.

Before the days of barbers, shaving and home perms, early man and woman must have been a weird sight. Beards could have been yards long and women's hair lengthy enough to keep an entire tribe warm.

Styles of moustaches seem to run in fashions. Sometimes these are apparently led by pop or film stars; occasionally they go off rapidly, as in the case of that demented dictator's appendage which was made notorious by cartoonists in World War II.

Drawing the hairs of a moustache requires a light touch and delicate lines, using a thin edge on a pencil, or a fine point with a pen. A black, or dark, moustache, is best done by leaving white flecks in it. Hair reflects light so this trick is useful. White hair, on the other hand, needs a few dark strands put in. See figure 28 and notice how each example has been handled. Some men grow their symbols of masculinity right over the top lip, while others trim them back short of it.

It's common for moustaches to compliment a beard. Figure 29 depicts such package models. Try drawing these, and the previous illustrations, in soft pencil, which is much easier to use than a pen.

Beards

When observing a crowd of people it's amazing how often attention is focused on a grand beard. They certainly make a face interesting, but are rather laborious to draw. In copying figure 29, you will have noticed how lots of fine lines are used which must all be drawn the way the hair grows. Concentration and patience is called for, but the task is not difficult.

Figure 30 shows a tough looking face. Study him; then draw him. A little more detail has been used although the drawing has still been kept simple. You could probably copy this illustration with one eye shut!

The face in figure 31 is that of an elderly man who has had a very hard life. Character and personality should be evident

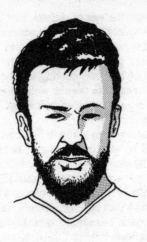

Fig. 30 Draw a tough-looking face.

in careful studies. The ability to bring out such traits in your art requires good observation and use of the right techniques.

Notice here, how use has been made of different types of shading. Observe the close, diagonal lines, and the cross-hatching, for the dark areas in the background and on the subject. Look at the top of the head and see how hair has been suggested rather than each individual strand drawn. Half the face is in shadow. This is seen via straightforward shading over the line sketch.

Below the portrait, I have reproduced the rough but accurate construction lines which were the foundation for the whole picture. Copy them first. Pencil will be best. Then complete the gentleman. The finished work should increase confidence and give a well earned sense of satisfaction.

Reminder

Many times I have seen promising newcomers suddenly forget to build drawings from a sound basic shape as above. Instead

they begin a sketch by trying to put down detail. This is the worst way. One wrong line will cause others to be out. Why make the job harder than it need be?

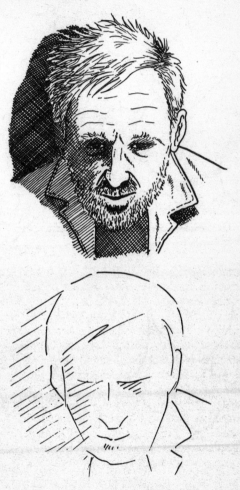

Fig. 31 Portrait of a character.

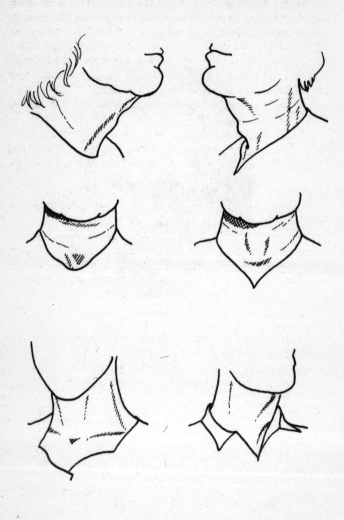

Fig. 32 Neck lines appear with age.

Suppose, for instance, that you see the profile of a beautiful person and begin an intended masterpiece by drawing the nose, a common starting point, but the angle and position are not quite right. You move on to the mouth line along with the face shape, but this doesn't seem correct so you make changes. Other features give you just as much trouble. The end result is a mess. Your beautiful person now resembles the hunchback of Nôtre Dame with a belly ache! Do you remember what I said about the framework of a shed?

A brilliant artist may *appear* to get by without putting down the outline first, but you can be sure that an over-all shape has been firmly fixed in that person's mind before a mark is made.

Have a neck

The female neck is longer, smoother, and more attractive generally, than the thick, short one of the male.

From your mid-twenties onwards your neck changes. It slowly gathers lines and folds. It may become scrawny, or fat. Figure 32 gives examples of middle-aged necks, both in profile and from the front. Below these are two sketches of young necks. Examine those of friends and try a little life drawing.

Assignments

1. Draw 4 moustaches, then 4 beards, either from life, or using photographs.
2. Sketch some young and old necks.
3. Try a detailed drawing similar to that in figure 31.

6

BRING ON THE WIG

What a magnificent range of hair styles there are — artistic, weird, tangled, wild, neat, and glorious. Some of those worn by men aren't bad either!

Drawing hair at close-quarters requires keen observation and an ability to simplify what is seen. Mostly it will be a matter of suggesting a fashion rather than of meticulous draughtsmanship. If you have a wonderful thatch and a mirror then you have an immediate model — you. If, like this author, your personal prop isn't up to much, then bring on the wig, or use friends.

Different styles

Have a look at the styles in figure 33. The top left one is of a gentleman with silver, wavy locks which have been created simply by means of a few lines, like those of the long-haired blonde opposite him. Shadows are depicted by slightly increasing the number of lines. This is more noticeable in the example of a pony-tail style as in the middle left drawing.

Black or very dark hair should not be shown as a solid mass. It's best to leave highlights in as shown on the other illustrations in figure 33.

Three of the hair styles in figure 34 have been produced by pen *and* brush. The broken, rough line effect is achieved by what is known as a dry brush technique. A fairly thick drawing ink is used on a small, good quality paint brush. This is first loaded with ink, and then most of the contents are wiped off on a piece of scrap paper. When the bristles are almost dry the brush is dragged across the area of the picture as required. The result is rather like that obtained with charcoal, which is also an excellent medium for portraits and figures. A similar effect can

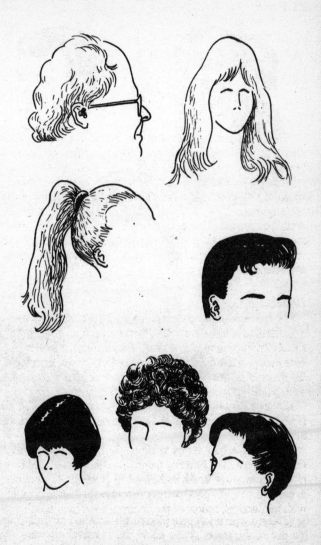

Fig. 33 Sketch various hair styles.

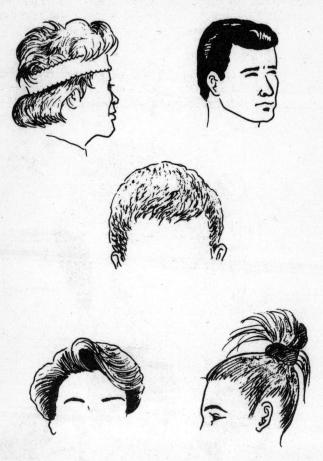

Fig. 34 Use pen and brush.

be achieved with a soft pencil on rough-surfaced cartridge paper.
It's one of the tricks of the trade and is useful on many other
subjects besides humans.

Points to remember when sketching hair are that it reflects

strong lights and has several degrees of tone. Those go from dense black through medium grey to white. It will help your progress to copy the examples in figures 33 and 34.

Crowning glory

Perhaps you are old enough to recall how the Beatles mop-head style swept round the world, and wasn't just confined to young men? Today, although the older generation may tend to

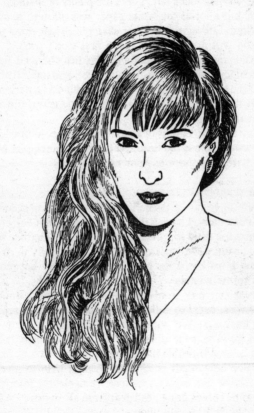

Fig. 35 Sketch fine hair.

stick to the same thatch, luckily there are thousands of youngsters who certainly do not. This makes our job much more interesting. Young ladies especially, may change their hair styles frequently. Some of them grow marvellous tresses which at first glance might appear to be difficult to draw. In practice it's a straight-forward task calling for patience and proper *looking*. Figure 35 is of such a model. The illustration took a little time due to having to put down masses of fine lines, most of which were curved and ran the way the locks fell. There are plenty of medium and dark tones, but a lot of the white paper was allowed to show through. Study all aspects of this example. Then draw your version. You will draw a basic shape first won't you?

You should now turn your attention to the men's heads in figure 36. The technique is just the same but there's less hair. The pen drawing at the top of this page is of a man with curly, dark hair. Notice how the waves have been recorded, and the way the lines go back at the sides of the head.

The illustration beneath is of a man with light coloured locks which are swept across the head. Not quite as much pen work is needed here. Try these as your next project.

Head gear

Hats seem to go out of fashion for years, and then suddenly reappear. Personally, I have a different one for each day of the week. Artists use them for practical reasons: it's helpful to have the eyes in shade when working outdoors, especially in strong sunlight and a hat keeps the head cool in summer but retains body heat in the winter.

Head wear can vary from a knotted handkerchief, through scarves, shades, caps, to full-scale productions that resemble a hanging basket packed with fruit or flowers.

It makes good sense to draw hats as the sole subject before attempting to sketch people under them. Have a look at figure 37 and notice how small patches of shading help to give an illusion of shape. See how seams have been clearly inscribed. It's useful to be able to draw head gear from all angles — which is how we see folk wearing hats.

A common error for beginners to make is to draw the lid too big or too small, so that the head does not appear to fit into

it the right way. The material in a hat is usually thin and follows the lines of the head very closely.

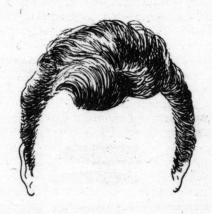

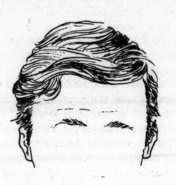

Fig. 36 Draw male hair styles.

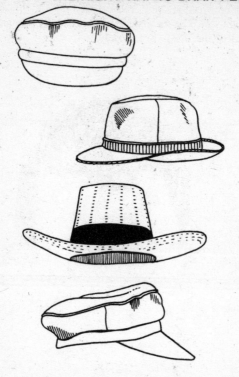

Fig. 37 Draw head wear accurately.

Figure 38 demonstrates how a brim can conceal eyebrows and sometimes eyes too. A peak can throw a strong shadow across the front of a face, as in the sketch at the top of the page. The hat may have a brim which sags down unevenly. Capturing that jaunty angle (of hat) is all about *looking*, yet again.

Assignments
1. Make two accurate sketches of the hair styles of a girl and of a young man.
2. Draw the hair of two older people.
3. Picture four different types of hat. People two of them.

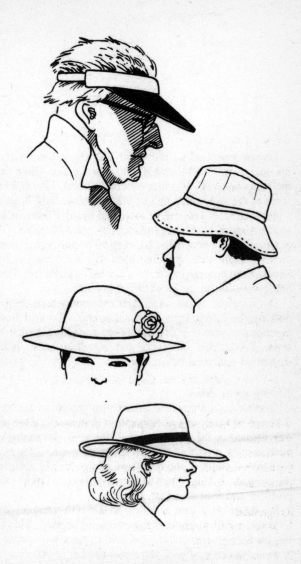

Fig. 38 Different types of hat.

7

THE ADVANCED FACE

Tricks of the trade

Having practised all the facial features in the assignments, it's time to 'put it all together' into a whole face. First, examine the many ways of obtaining different effects. Figure 39 shows some of these. Shading can be made in close tight lines to give a grey-like tone. This can be increased by thick lines for a dense look. Almost black is produced by cross-hatching. This is achieved by drawing diagonal, vertical or horizontal lines, then crossing them with opposing lines. It's a common technique. Shading can be straight, broken, curved or scribbled. The latter being very useful for depicting fine hair.

Dot stippling, in ink, is another commonly used device. The dots can be heavy, light, thick or sparse. You will find after practice that your own inventions and style decide what will be used. Remember, however, that all these aids should be structured and tried before use.

Scaling up or down

Graphic and commercial artists who require an accurate but different-size copy of a photograph or drawing often use scaling. The method is easy but time consuming. If, for example, you wish to draw a portrait of your favourite uncle — the rich one with the oil wells — and only have a large-sized photograph of the old goat, scaling down to a smaller version could solve the problem and lead to a vast inheritance.

See figure 40. A grid is drawn, in ink, on a transparent sheet. Two-and-a-half centimetre squares could be used. This is then laid over the master picture and held in place with paper clips. A scaled-down grid with the same number of squares is then made lightly, in pencil, on the drawing surface. To make the

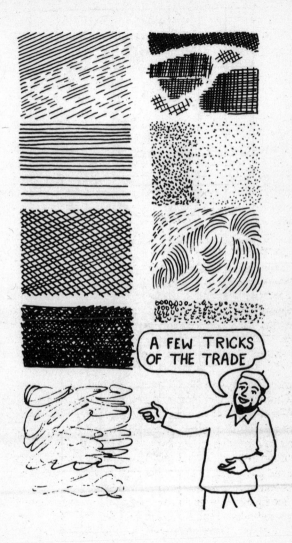

Fig. 39 All kinds of shading.

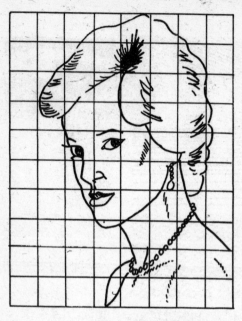

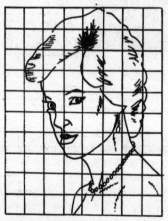

Fig. 40 Scale up or down.

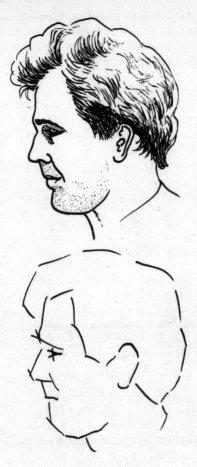

Fig. 41 Draw the basic structure first.

sketch you just follow what is in each square of the master as you reduce it down to fit the relative square on your smaller drawing. A fast sketch of the very attractive Princess Diana was produced in the example. This author will once again miss out on the birthday honours list!

This technique is good for giving confidence to students, not that you need any, and it's most valuable as an exercise in *looking* accurately. The grid can also be used in reverse, for increasing the size of a photograph or drawing.

Girls, sketch your hunky hero

Your boyfriend or husband could be your favourite-looking hero, but, if not, there are plenty of pictures of film and pop stars about. Most daily newspapers carry several pages devoted to gossip about celebrities.

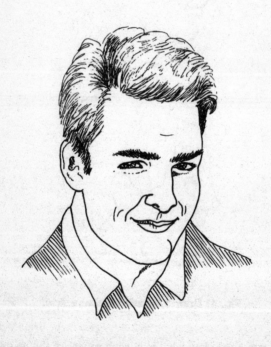

Fig. 42 Use simple shading.

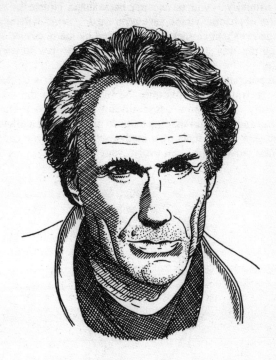

Fig. 43 Cross-hatch shading is useful.

Always start off by having a long careful look. Then pop down the basic shape. See figure 41. This has fairly simple, clean lines, with just a bit of dot stipple for the designer-stubble which seems to be a current fad. Notice how areas of white have been left in the hair to suggest the shine of a well groomed head.

Now that you are bursting with confidence you may care to draw a face like that in figure 42, which makes another easy exercise.

The strong, magnetic looks of Clint Eastwood in figure 43, are intended to be a greater challenge for you. You could try scaling this one from the book to a larger size. Otherwise start

off — naturally — with an accurate basic shape. Notice the many varieties of shading which have been used — cross-hatching on face shadows and clothes, hair recorded by many curved lines flowing the way it grows, stipple dots on the jaw to suggest stubble.

The portrait of the unknown man in figure 44 is treated in the same way, but in this one, the light plays on the subject differently. Notice how dense shadow is obtained by cross-hatching and how this shading helps to give depth to a drawing. Artists tend to use their own methods. However, you can use the ones shown, until you evolve your own style.

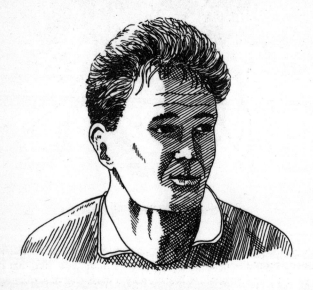

Fig. 44 More useful shading.

Men, draw your special girl

You might know a pretty girl or be lucky enough to be married to one! If not, don't worry, there's 'armies' of them about, especially in magazines, and other media. Beautiful faces help sell many products. An attractive female face though is not as

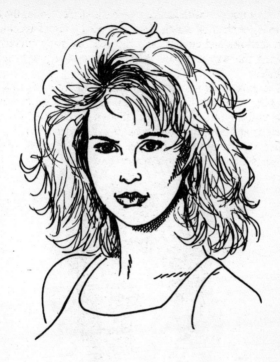

Fig. 45 A 'scribbled' hair effect.

easy to sketch as the rugged, rough mug of a man. Delicate, clean, simple lines are required. Some hairstyles, like that in figure 45 for instance, are best done by a loose sort of scribbling, with just one or two dark areas around the sides of the head to prevent the whole from looking flat.

The dark haired girl in figure 46 was laboriously drawn with much fast, loose scribbling to depict the hair, in preference to blocking it in. The tanned skin was produced for the purposes of reproduction in this book, with a mechancial tint rather than fine lines. A pencil could be used to obtain a similar result. Try copying the above illustrations in pencil or ink.

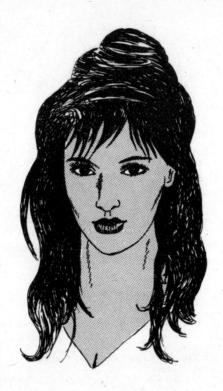

Fig. 46 A lot of fine lines for the hair.

Golden oldies

Without doubt mature people are the best subjects for an aspiring artist to sketch. Features are distinctive, and age lines help. The portrait in figure 47 is of a Hungarian lady who is a talented artist. The picture was produced in one minute after *looking* for three. Giving yourself a short time limit is a good method to practise, and often the best drawings happen this way.

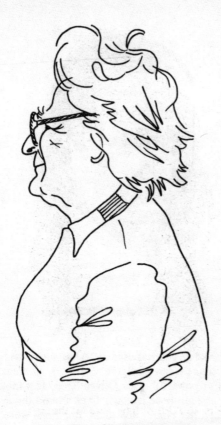

Fig. 47 A one minute portrait.

Notice the loose, sketchy style and scribbled hair. The illustration was done straight off with a fairly fine drawing pen.

Figure 48 shows a wonderful countenance to draw. It belongs to an ex-president of the good old USA. Dot stipple has been used with lots of fine cross-hatching. The eyes have been blocked in and show no highlights. The hair appeared to be dark and

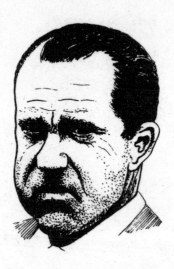

Fig. 48 Dot stipple is an aid.

greasy so a thick line pen was used and white streaks were left in.

A face such as the one in figure 49 is a joy to draw. It's the famous head of powerful actor Oliver Reed. Just look at that happy smile and all those laughter lines around the eyes. The teeth have been left blank, and many fine lines were used to record the moustache and beard. Try copying the examples in figures 48 and 49.

Assignments
1. Draw your favourite person.
2. Draw two famous people, a man and a woman.
3. Scale a photograph up or down. Draw your version in pencil or ink.

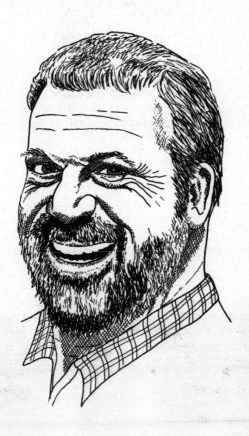

Fig. 49 Draw a powerful face.

8

HANDS AND FEET

Most beginner artists draw hands and feet far too small and incorrectly. Surprisingly, it's a common fault with more experienced artists too. A tip to help you avoid this is to remember that a hand, from palm base to fingertips, is as long

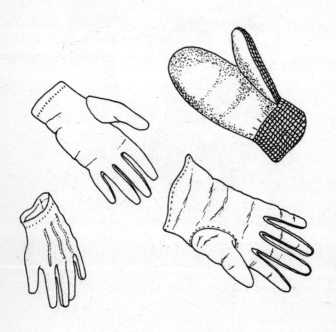

Fig. 50 Gloves are hand-like.

as a face. Compare yours now. A foot is bigger still. It measures slightly more than the length of the entire head. Don't try to check yours without a ruler or you may do yourself an injury!

Students don't spend enough time *looking* properly or practising drawing these extremities. They may seem difficult to draw but really they are no harder to do than other parts of the human body. We can use ourselves or friends as models, so there is no problem finding different examples.

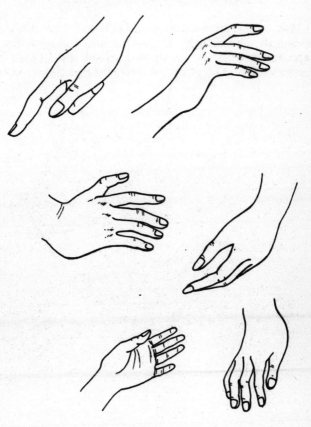

Fig. 51 The female hand.

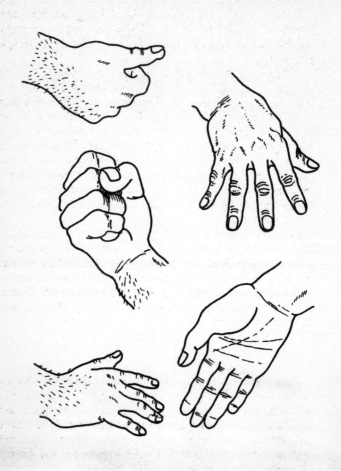

Fig. 52 Men's hands.

Be handy

Sketching gloves is a simple way to start learning how to draw hands. The basic shape of a hand is similar to a mitten. They

are easy to draw. See figure 50. Ladies' gloves are usually made to fit more exactly over fingers and hand than gentlemen's ones. Note how hand-like gloves are, and after studying the ink stipple and fine lines of figure 50, have a shot at copying these examples accurately.

You can use your non-drawing hand as a model. A mirror will enable several angles to be viewed, then drawn. The back of the hand, you will discover, is gently curved in convex fashion, while the underside is concave. The fingers follow a shallow curve from the top of the palm. There are three finger joints which show as lines, but these do not correspond exactly, because of the fingers having different lengths. The cushions at each fingertip vary from person to person, and knuckles may be prominent or barely seen. Old hands carry wrinkles on the fingers and the backs of the hand, but it isn't necessary to try to put them all in.

By now you should be wise and experienced enough to know that the idea is to *suggest* rather than laboriously attempt to get down every tiny detail. You probably don't need telling that there is a big difference between the soft, usually beautiful hands of girls and the rough, blunt-fingered hairy paws of men. Examine the illustrations in figures 51 and 52. Then copy them in pencil or fibre-tip pen.

Best foot forward

Once more, you can practise drawing feet by using your own or those of friends. The foot seen sideways is wedge shaped as are most boots and shoes. From the front the toes appear to be broad due to them being nearest to the beholder. (That's called perspective.) However, viewed from above, the toes seem to be pointed or narrow. The same applies to footwear and this is an important point to remember when sketching.

The marvellous human foot is constructed in the form of a series of arches which make it super strong, flexible and able to withstand constant shock. Ankle joints protrude from each side, the inside knuckle being lower than its outside partner. The ball of the foot is quite large, and the heel is no midget either. Study figure 53 and copy.

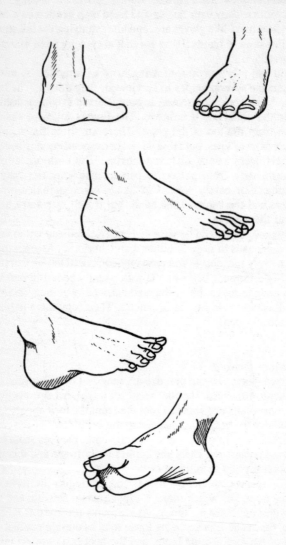

Fig. 53 The foot – from different angles.

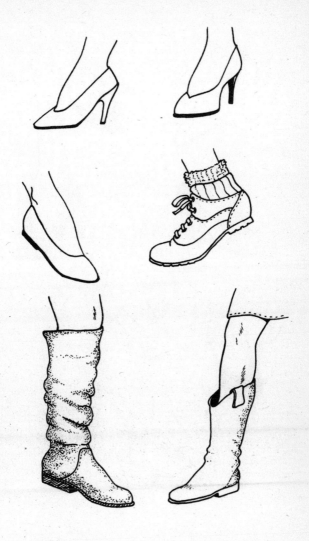

Fig. 54 Drawing footwear is good practice.

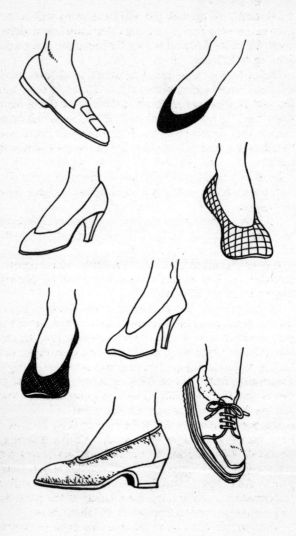

Fig. 55 Popular styles.

Get your shoes on

Practically all the folk you will be drawing will be wearing footwear of some kind, so it is logical to learn how to draw these items. Sketching footwear is good for improving observation and drawing techniques.

Ladies have a huge range of styles to choose from, and fashions change, sometimes quite fast. The court shoe, however, seems to be ever popular. Look at those at the top of figure 54. Apart from the possible addition of bows, bells, and from their colours, they remain pretty much the same year in and year out. Note how the heel bulges out and then sweeps down to the toe position.

Boots are fashionable. Flat heeled shoes are quite common with leisure dress, and sports shoes abound. Figure 55 shows more styles.

See how all these examples have been drawn. Your eagle eye will pick out the way the foot arches out of a shoe, and the way ankles appear from side and front.

Footwear is made from many materials. These figures show how dot stippling and other techniques can be employed to suggest what has been used.

Men's footwear has undergone many changes in the past decade, but there are still scores of styles which haven't altered very much. A good way to start on footwear is to dig out your own and draw what you find, as I did for the examples in figure 56. The sketch at the top of the page was produced having placed a mirror opposite my feet. Most of us have a favourite pair or two of shoes; those depicted happen to be mine — worn out and the despair of repairers far and wide!

Old boots and shoes tend to be nicer to draw because of age lines, bumps, and bulges — it sounds a bit like sketching faces doesn't it? When looking at your own foot gear, work out how you are going to suggest the fabric used before you mark your paper. And note carefully where the seams will show. Experienced artists develop these habits to the point they no longer have to remind themselves to follow them.

Most people could read through this book in one sitting. However, to get the most out of it, go carefully, and force yourself to do all the assignments. Right?

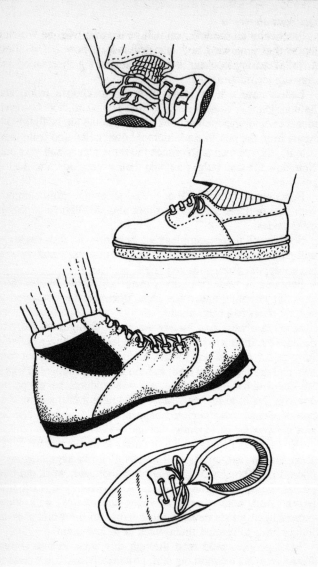

Fig. 56 The author's foot gear.

Assignments
1. Draw two pages of hands, your own and friends'.
2. Do the same with feet, and footwear.
3. Draw 6 old and 6 modern shoe styles.

9

ARMS AND LEGS

Ladies, of course, come first, so I will start on their lovely flowing lines. Members of the fairer sex have more flexible elbows than men so we can see in them poses which fellows can't equal. Female arms hang closer to the body than those of men, and their forearms are slightly shorter than those of the male. This is probably due to early man being the hunter, having to hurl a spear about, club enemies, and lift heavy rocks.

The arm is quite long, and the old yard measurement may have been based on this fact. If you stand up and drop your arms down you will find that your fingertips reach the middle of your thighs. If your hands are level with your ankles you're an ape, but don't worry, chimps can learn to draw!

Take a peep at figure 57. See how the upper arm is shorter than the forearm. All women have a layer of fat beneath their skin, which is responsible for their smooth, streamlined shape compared to men. Copy the illustrations. Then draw the arms of ladies around and about.

Muscle power

Figure 58 shows the ripples, bulges and potential power seen in a man's arm. Note the pronounced shoulder muscle, and the biceps and upper arm which are designed to bend the limb. The triceps in the lower arm are usually obvious too, and most fellows have hairs on their arms and hands. Try to remember how the arm looks from either side, as well as from the front and rear. This will help you with future work.

On with the sleeves

Most folk you will sketch will be clothed, so you need to spend time and thought on how to draw their garments. Ladies, bless them, expose their arms and legs far more than chaps, but you

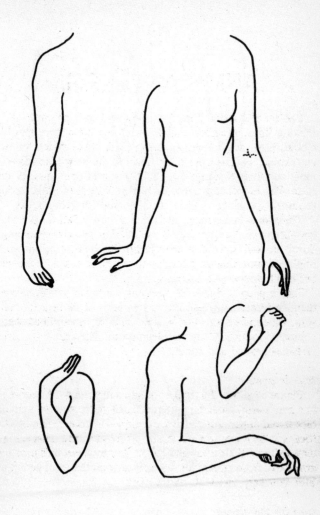

Fig. 57 Smooth ladies' arms.

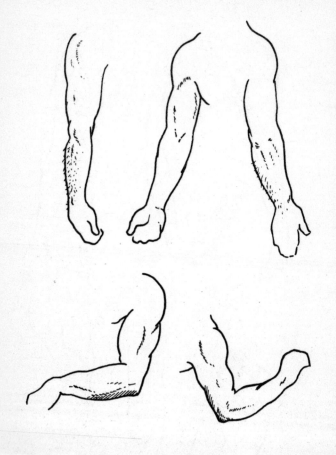

Fig. 58 A man's muscle.

must still learn how to use a pen or pencil to depict material, as part of your apprenticeship. So, indoors or outside, get into the habit of observing the way clothes hang, crease and fold. It's all about *looking*, isn't it?

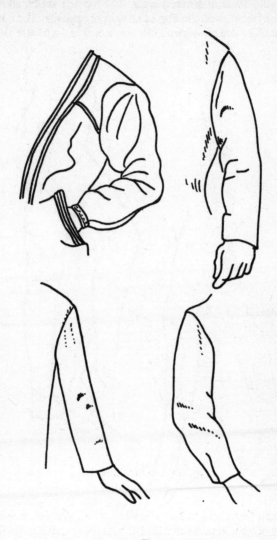

Fig. 59 Different sleeves.

Figure 59 is of covered arms. The top left sketch shows a leather jacket, with the arm of an anorak opposite. The bottom two designs are of women's clothes, a coat and a blouse sleeve.

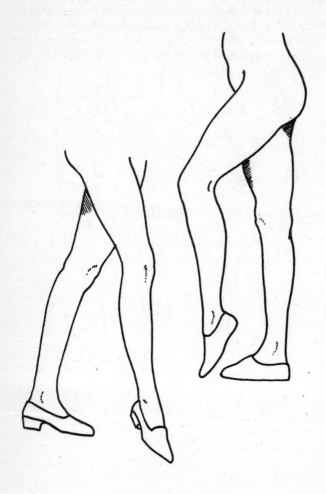

Fig. 60. A model's legs.

Getting the legs 'together'

The length of a leg is roughly half the body's height. Some ladies, particularly model types, exceed this measurement and are much in demand in the advertising field. The legs of a model were used in figure 60. Notice the nice smooth, curved contours. These are best drawn in one sweeping motion. Look at the two small bumps which depict the knee cap, then at the tiny swelling behind the knee and at the way the line of the thigh runs into the buttock.

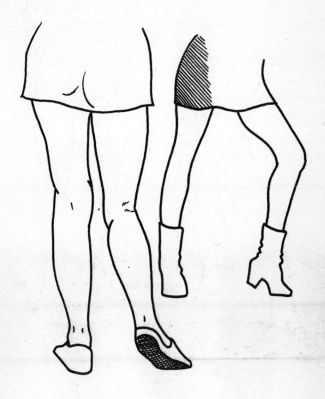

Fig. 61 Legs from different angles.

Figure 61 shows female legs from front, side and rear. There is an obvious bulge on the inside of each knee seen from behind. Beginners tend not to notice it, and, as a result, scrawl a couple of straight props for legs.

Perhaps this is the moment to mention that there are *no* straight lines in the human body; all are gentle curves of one kind or another.

Stocking tops

Stockings are supposed to be making a come back against tights. Did your author hear three cheers from the older lads?

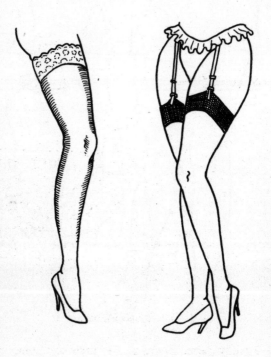

Fig. 62 Stockings.

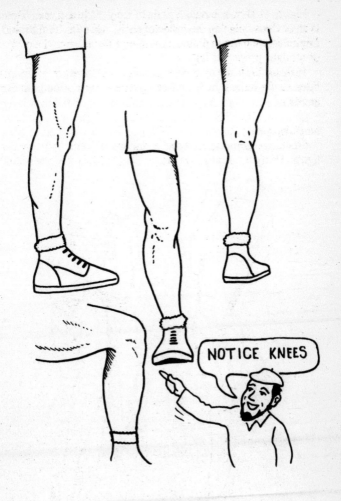

Fig. 63 Men's pins.

These pretty garments are nice to draw and come in many shades, styles and designs. There are the kind that are held up by suspenders and a belt, and some that need *no* bits and pieces

to stay put. Isn't science wonderful? Figure 62 gives an example of each. Note the way the roundness of the thigh is followed by the line of the stocking top.

Power pins

Men's legs are shown in figure 63. It's noticeable how the appearance of thigh and calf muscles is not subdued by a layer of fat as in girls. That feminine padding, by the way, protects them from cold, and minor ailments, and is believed to be a factor in longevity. Is there no justice?

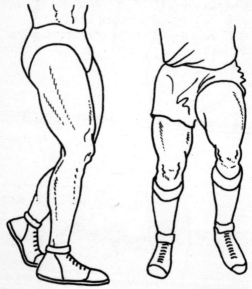

Fig. 64 Sportsmen's legs.

Sportsmen tune up their muscles and thus help an artist to see what's what. Glance at figure 64; then try copying the two athletes. The back pages of most newspapers contain many photographs of sporting gentlemen who you can draw, whether they be whacking a cricket ball, kicking a football, or punching someone's head.

To expand your work on this chapter you can find numerous models around you to dash off onto your action-pad. Draw a basic shape first. Don't stop at legs — include body, arms, hands and heads. We'll have no lolling about, drinking cups of tea, or watching TV during this important stage in your rapid progress. However, you may pause to whistle a happy tune before setting about the assignments below!

Assignments
1. Sketch four exposed arms and legs in poses different from the examples given.
2. Draw six fully-clothed arms and legs.
3. Draw all the examples in this chapter which you haven't already done.

10

THE TORSO AND BIG END

Almost all artists have an eye for a beautiful body, but not many beginners have the opportunity, or perhaps the confidence, to attend a life drawing class to learn this skill. If this applies to you don't worry. There are other ways of learning how to sketch the human figure. The female form is the one most used, published, drawn or painted. The male frame, in comparison, is rather plain and not nearly as curvaceous.

Stone Age artists depicted their women folk as having huge buttocks. We now believe that this was the way they actually were. When mankind first stopped crawling about and stood up, the powerful gluteal muscles were responsible for holding up the body weight. Since then the human form has changed and continues to alter. Modern woman has evolved to own narrower hips, a deeper, flatter tummy and generally quite pronounced, rounded breasts. She no longer looks like a cave woman — thank goodness.

A thing of beauty

There's more to drawing the female figure than there is to doing that of a man. The female torso and posterior, for example, often seem heavier, in size, than their male counterparts, due to the layer of fatty tissue women carry. Figure 65 gives the basic structure of a front pose, then the sketch. Below are back and profile views.

When we were children our elders said: "sit up straight", or "stand up straight". They were impossible requests because the human spine is curved, as you can see from my illustration. You will also spot the way the neck leaves the upper trunk at a distinct angle, as I mentioned in an earlier chapter. Notice too, the mass of muscle in buttocks and hips, and how the belly curves gently

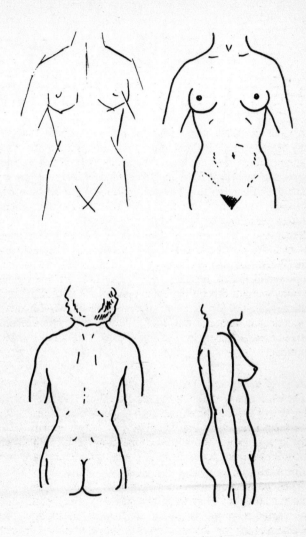

Fig. 65 Draw beautiful bodies.

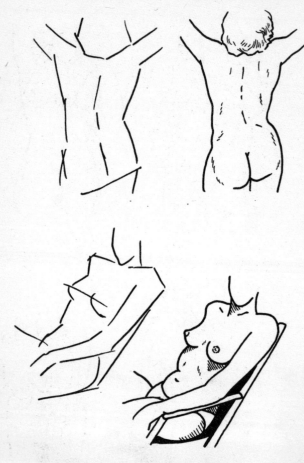

Fig. 66 Notice the construction lines.

out. These are all important points to remember when you are drawing people.

If you draw over- and under-weight people first, you will learn rapidly the extent to which bodies differ. My subjects here were

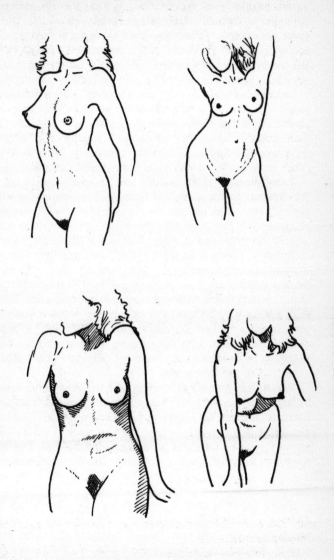

Fig. 67 See how fine shading works.

normal healthy types. Nevertheless, you can see how each part is unique to the individual, just as facial features are. Breast shape, for example, varies considerably between women and also according to age. Perfection in this department happens in the late teens when bosoms are firm and round. From then on mammary glands become heavier and gravity pull causes them to sag.

Ladies undulate and sway when moving. This affects their shape and gives us artists problems, but ones which we can confidently solve. Figure 66 shows a girl's back with her hips tilted, and this makes the buttock shape slightly different from the previous example. The basic construction lines show the subtle changes. This is why an accurate outline sketch is so vital.

Today, on many sunny holiday beaches, young ladies can be seen topless, like the example in figure 66. Mass-circulation daily papers carry so-called pin up photographs of well-endowed young models. Books on photography and art can provide other sources. So there is no shortage of subjects available for practice.

Study each body in figure 67. Note how just a little fine pen shading can emphasise breast, belly and hip shapes. Look at the way bosoms are from different angles. The female belly is more rounded than a man's. A torso can be long, short, fat or thin; a waist may be high, low or average. In these examples you can see a midline depression running from navel to lower chest. This is caused by side muscles meeting, and has been suggested by shading in the drawings. This line is not visible in the old or the overweight.

You can use yourself as a model with the aid of a full-length or large mirror — why not? Many famous artists churn out self-portraits. Vincent Van Gogh, as we all know, recorded his own anguished face regularly. I have been tempted to immortalise my own battered mug and gaunt frame but, to date, I haven't got round to actually doing it. Be thankful for small mercies!

Put the clothes on

Figure 68, of clothed figures, shows how material can be drawn to give the viewer an idea of the form beneath it. Creases and folds usually help to do this. A swim suit makes the body easy to sketch because this garment irons out lines, sags and small bulges.

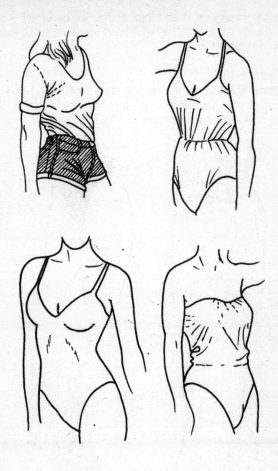

Fig. 68 Clothes show form.

Take a squint at figure 69 to learn how the covered bottom is drawn. The backside is something we frequently see. So it's useful to carry a small (A6) size sketch pad around when shopping or observing humanity. Lots of practice can then be obtained without the victims being aware.

Before moving on, draw all the bodies you have been looking at in figures 65 to 69. Start with basic structure lines, then jot down complete forms.

The male body

Figure 70 illustrates the average male torso, and, below, that of a boxer who has had to develop powerful hitting muscles in arms, back, chest and shoulders. The same over-development

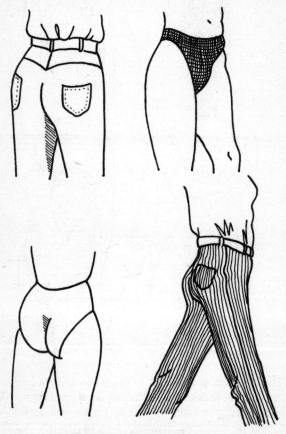

Fig. 69 The clothed backside.

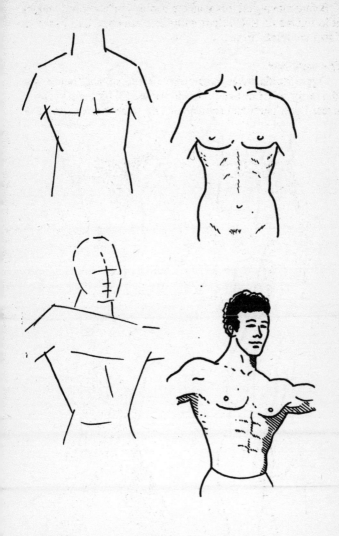

Fig. 70 Draw the construction lines first.

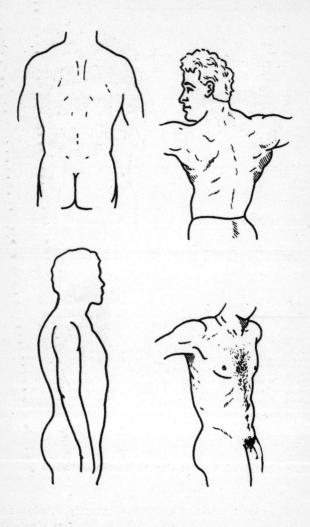

Fig. 71 See how muscle groups are drawn.

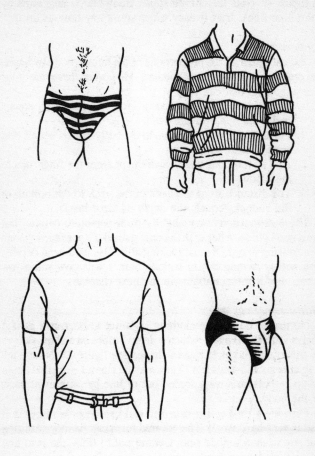

Fig. 72 Pay attention to creases and folds.

occurs in those individuals who, in sports jargon, pump iron.
Notice the clearly defined muscles each side of the midline depression, the narrow hips, wide shoulders and bulging muscles. You can see how these specimens look from the rear

in figure 71. Note the curved spine. Body hair is suggested by short fine lines. Isn't it easy when you know how to do it?

Proportions

You can learn all the proportions of the human body by heart. In practice you need not bother. However, there are four measurements that can help you:

1. The width of the upper body, including the arms, equals twice the depth of the head.
2. The distance from the chin to the belly-button equals that same measurement.
3. And so too does the measurement from the fingertips to the elbow.
4. The distance from the back of the neck to the bottom of the buttocks equals the depth of three heads.

These proportions vary slightly from person to person, but are a good guide. After experience is gained it's possible to judge if a drawing is right by just looking at it. Use bald head depths. You will go wrong if you include hair. I will give you a few more, useful measurements in the next chapter.

Throw some togs on

No matter how loose clothing is, it has to be drawn as if it covers a sturdy frame — which it does. Stripes on a shirt, sleeves or trunks can aid us to record shape. See figure 72. Notice the way creases and folds run. They may be curved — pulled down or up — but are always forced out of line by prominent parts of the body.

Drawing a motionless naked model can become rather dull and is very hard work. The covered form can be more exciting and erotic than a nude one. Getting out to draw the revolting peasants is lots of fun!

Sitting unseen in a café, art gallery, or library sketching people as they relax is rewarding and super practice. It's also the fastest way of becoming a good artist; try it.

The action men, in figure 73, show the way clothes can suggest power and movement. The sporting pages of newspapers will provide dozens of photographs of subjects in lots of different sports wearing a wide range of gear. Save a few old copies for

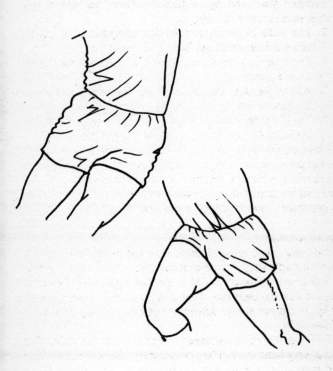

Fig. 73 How clothes suggest movement.

practice but don't limit yourself to just torso and big end; go for the whole figure. You can do it.

Assignments
1. Return to the drawings in this section which you haven't already copied, and tackle each one. I need not remind you how to *start* every time!
2. Draw 6 female bodies, clothed and unclothed.
3. Sketch 6 action drawings from newspaper cuttings.

11

PUT IT ALL TOGETHER

We draw best that which we know. It follows that to be good at drawing people some knowledge of anatomy is necessary. By doing the suggested exercises in past chapters you have been gaining this know-how, so you already have a good idea of how arms, legs, bodies, and other parts are constructed. Therefore, putting it all together should now be fairly straightforward.

A soft pencil such as a 4B is useful for figure drawing. Charcoal (which is burnt wood) is also excellent. Charred twigs were used by early caveman artists and still remain a common tool for the modern craftsman. Today, however, most artists' charcoal comes in smoothly prepared sticks. They give a dense black, with the ability also to create graduated tones that help you obtain a flesh-like effect on areas of skin. It smudges very readily but finished work can be fixed with an art or a hair spray. Sprays should be lightly used. It is wise to apply them from a distance rather than close-up.

Copying is an aid to successful drawing

Throughout these pages I have asked you to copy the illustrations. Almost all beginner artists start off this way, and you shouldn't think of this as cheating. Copying is valuable because it teaches you how to *look* properly and how to draw accurately — the basis of all good art. A first class copy of a drawing requires great ability. Drawing from life, in fact, is copying what is seen. The big difference is in the mind; the degree of self-confidence is different — that's all. After experience has been gained, copying is replaced by working from life or doing your own thing.

The nude model

You might not have a spouse, relative or friend willing to shed their threads, and life drawing classes may be out of reach; however, as I suggested earlier, photographs can provide an alternative source of subjects to work from.

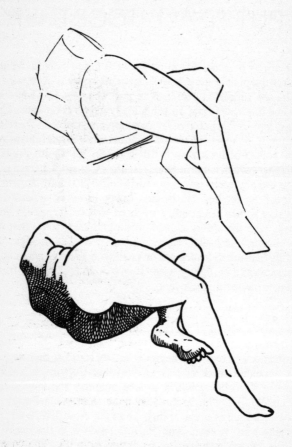

Fig. 74 Draw an unusual pose.

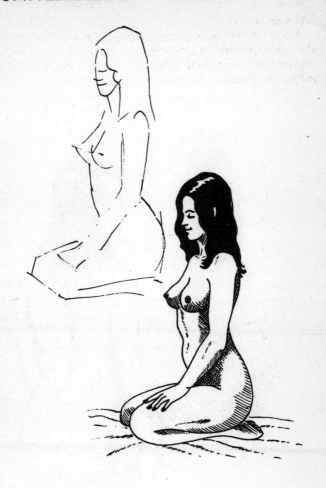

Fig. 75 An easy pose to draw.

The model in figure 74 was drawn from life. The pose was unusual, with dark shadows, and had the appearance of being a headless body. First the basic structure was put down in pencil.

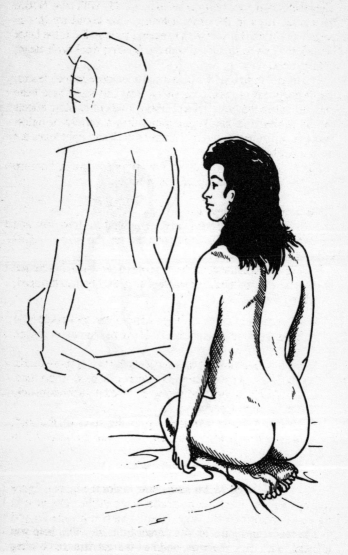

Fig. 76 Notice the shading.

Then the drawing was able to be done quickly with pen. Notice the curved lines in the cross-hatching. You could try this in pencil, or charcoal if you wish to extend your skills. If the latter is used don't try to smudge it with the fingers; work with clean, bold strokes.

The model in figure 75 sits in a common pose in life classes, and is fairly easy to draw. Shoulder, arm and spine have been mapped out in the basic sketch. Many kinds of shadow effects can be achieved in any studio which has a variety of lights. Interesting pictures showing a range of dark and light tones are made possible.

Figure 76 is not hard to draw. Try this one in ink or fibre-tip pen. See how the shading has been done.

More, useful measurements

As previously mentioned, beginners tend to draw feet and hands too small, but you will have mastered this now — right? Good for you!

Here are the additional guides to proportions which I promised to give you. All the measurements relate to the depth of the head, as before, bald as ever:

1. From the top of the leg to the sole of the foot equals 3½ times the depth of the head. This can be 4 times, or longer, in a model girl.
2. From knee to sole of foot accounts for two of those heads.
3. The length of the upper arm is equal to the depth of the head.
4. The length of the hand and wrist together, approximately equals that of one head depth.
5. The body, from shoulder top to the soles of the foot, usually stands 6½ heads tall, but it can go beyond 7 in some people.
6. Hips are usually 1½ heads wide.

It's possible to construct a line drawing of the human figure just by knowing what the proportions should be. The man in figure 77 was drawn this way. It could be worthwhile for you to try this. When you sketch a standing figure it will help you to refer back to the previous chapters, on arms, legs and bodies, as well, in order to get them right.

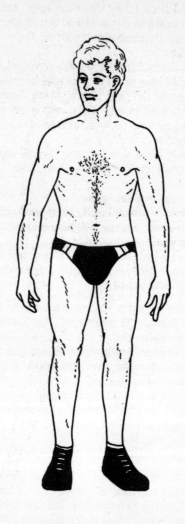

Fig. 77 Knowing proportions will help you.

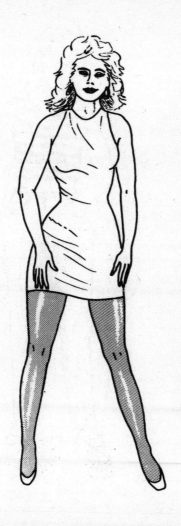

Fig. 78 Use simple lines.

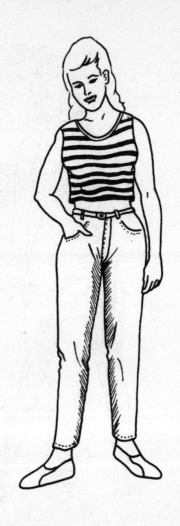

Fig. 79 Copy this one.

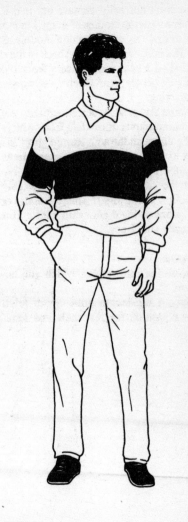

Fig. 80 Use blocking in.

Clothed models

As we don't normally venture out into a naturist world our subjects are wearing clothes of many kinds and styles. It's super practice to draw as many fashion models as you can, male and female. The mini-skirt, invented back in the sixties, still regularly appears. (Did I hear more cheers from lads and lassies of all ages?) Young people wear a weird and wonderful range of clothes worth drawing.

Magazine and newspaper advertisements and junk mail, all contain photographs of models from which you can work, and you will gain much through learning how to depict smart clothes and how to draw good-to-look-at specimens of the human race.

Study the illustrations in figures 78, 79, and 80. Cast your eye over the simple fashions and how they have been drawn. Pay attention to the figure shapes; then copy each drawing in pencil, before trying them again with a fibre-tip pen, charcoal, or whatever you fancy.

Assignments

1. Draw all the illustrations which you have yet to try in this section.
2. Produce 4 full-length drawings of relatives or friends.
3. Draw 6 fashion figures, male and female.

12

THERE ARE PLENTY ABOUT

In chapter 1 you sampled drawing people in a simple way without much detail. Since then you have tackled the individual features that combine to form the human body. Now you should be ready to produce accurate sketches of some of the human race — there are plenty of us about — *the Right Way*.

Motionless ones for starters

Sleeping people are a good starting point. The gentleman in figure 81 was having a nap in a busy city centre when a quick small sketch was made of him. This was later re-drawn double the size of the original. The finished picture was done with a fibre-tip pen, which gave a fairly thick line. See the way cross-hatching has been used. Small dots suggest the stone surface of the bench support.

Other easy subjects are people who are so engrossed with what they are doing that they appear still for long spells. Have a look at the study of a young man reading in figure 82. This illustration was made with a fine line pen to give a sketchy effect.

People watching, waiting, or chatting are useful models for budding artists. It pays to churn out dozens of fast impressions. The more you draw the better you will become, and, all the time, observation improves. You can't fail to make progress can you? Experiment with different drawing implements to extend your range and discover which medium you like best. When you change from sketching in pencil to drawing with a pen you may be surprised how much your concentration increases as does your skill. I have found this particularly noticeable when I switch a whole group of beginner artists from pencil to pen.

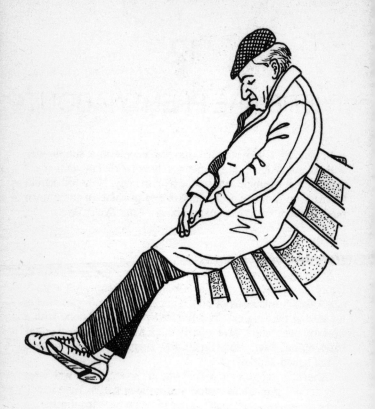

Fig. 81 Sleeping man – drawn from life.

Be an observer

When you haven't time to stop and sketch an interesting person you happen upon, develop the habit of mental drawing. Run an imaginary pencil over the face, along the body, down the legs. This is wonderful practice. Try it.

When people are going about their daily lives we can see what their arms, legs, hands and bodies are doing, and we can try to memorize those shapes and forms. The key to success is a

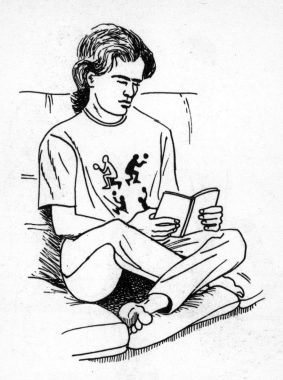

Fig. 82 Try using a sketchy effect.

long hard *look*. Then store away in your memory computer what you have seen. It's amazing how fast a mental drawing can be made. The time can be measured in seconds rather than minutes. Speed comes with practice.

The folk in figure 83 were popped down on an A6 pad and were about 5″ tall — the sketches not the people! A fine line fibre-tip pen was used and detail left out. Notice how posture, movement and clothes were treated. For reproduction in this book I have used some mechanical tints on the ladies' clothes. You would simply choose a suitable artistic technique for the effect you were aiming at.

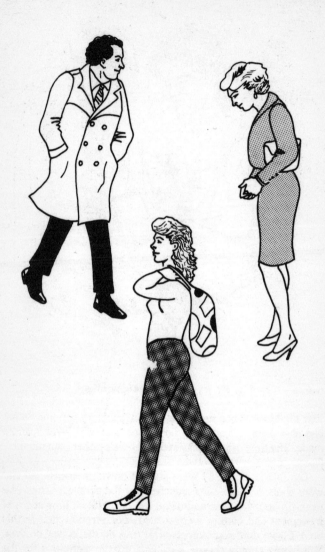

Fig. 83 Small drawings are useful.

Fig. 84 Note the artist working in the rain!

Fig. 85 Try to capture movement.

Figure 84 shows more humans. Note the keen artist working in the rain! Make basic structures in pencil. Then work in black ink.

If your ambition is to draw as a fun hobby, you should have almost reached that level already. If not, you surely will have done so in, shall we say, three weeks from now?

Fig. 86 An impression of power.

The serious full-length study of a person, however, requires rather more time and patience, and high skill. If you aim to specialise in this type of work you only have to practise that much more — preferably as much as possible on live models.

Ordinary people love being drawn provided the artist does a reasonable job, but it's not wise to unleash yourself on the general public if the end result always looks like a stick figure that has gone wrong! Start with friends or easy-going relatives. Your author once knocked out a cartoon of a fellow-walker during a lunch stop. The victim objected on the ground that the character didn't look like him. He was handed a pencil and sketch pad and invited to draw the artist. It was a mistake. The finished picture resembled a cross between Mr Punch with toothache, and Quasimodo on a bad day. Some people need their vision tested as well as art lessons!

Action people

Our eyes are not quick enough to pick up fast movement in the human figure, but still-photography and TV video (on pause), can help us with this problem. The action is frozen so we can have a good look.

Figure 85 shows a girl sprinting. Notice how the taut lines, suggested muscle groups, and the creases in the clothes all help to convey an impression of power and movement. The same is true of the tennis player in figure 86.

Getting the basic structure right, yet again, is all-important in studies like these. With this in mind the humans in figure 87 were drawn with a large paint brush (a number 16), so that no details could be put in. I give this exercise to guests on my activity holidays as a way of showing how to record the shape of people quickly. You might care to try it out from life or photographs.

Reminders

1. Enjoy drawing.
2. *Look* long and properly.
3. Build your drawings on accurate basic shapes.
4. Expect many mistakes but *let them help you*.
5. Know that you CAN be successful.

Fig. 87 Drawn with a largish brush.

13

DRAW FROM YOUR IMAGINATION

Creative people need, and use, their imagination. This ability to see pictures on your mental screen can be very useful to draw from.

For example, I write children's books that require drawings of witches, dragons and children. I use images which flash into my mind. It is possible to hold, and later to recall such pictures. Figure 88 shows some witches that I created.

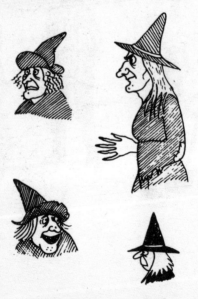

Fig. 88 Witches conjured up.

Children, by the way, are one of the most difficult subjects for the beginner artist. A child has a smooth face, with no age lines, wrinkles, or strongly defined features. So a lively youngster requires intense concentration and great accuracy. However, cartoon-style characters can be conjured up in your mind. Figure 89 shows some of mine. You might like to try this technique. You could produce Piccasso-type pictures, or realistic ones. It's worth doing to gain experience — or just for fun!

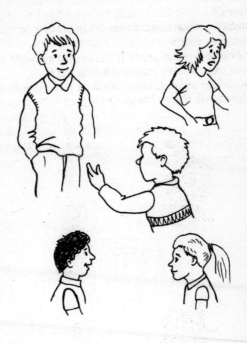

Fig. 89 Imagined children.

14

FRAMED

A proper frame enhances the original drawing. The cost of having this work professionally done can be high, but you can do-it-yourself.

It provides a nicer focus if your original has a border round it. Always give your work space. Many newcomers don't, and spoil an otherwise good picture. Working to a standard size — A5, or A4, also helps to make framing easy.

You will need a sharp cutting blade, a ruler, mounting card, and a ready-made frame. The mount is used to keep the original away from the glass. The layer of air made possible by this prevents sticking, and helps to reduce fading. (Incidentally, pictures should never be hung in direct sunlight, or over a fire, heater or radiator.)

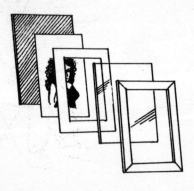

Fig. 90 Framing.

The mount should be carefully cut to give a well-proportioned border to the picture. This is where the ruler and sharp blade come in. Mark the lines lightly in pencil before cutting. The surround can be coloured, or neutral. You may care to choose a mount that blends with background decor.

The ready-made frame should match the picture. Generally, a light picture needs a light frame, a dark one requires a dark coloured frame. There is a wide choice available. Figure 90 shows the component parts, and how they go together. There is a backing sheet, or plate, the original, a mount, then the glass and frame.